Sue Mason

Flowers of Love

A Kew Colouring Book

Kew Publishing
Royal Botanic Gardens, Kew

Published in 2015 by the Royal Botanic Gardens, Kew,
Royal Botanic Gardens, Kew, Richmond, Surrey, TW9 3AB, UK
www.kew.org

ISBN 978 1 84246 613 1

Distributed on behalf of the Royal Botanic Gardens, Kew in North America by the University of Chicago Press, 1427 East 60th Street, Chicago, IL 60637, USA.

British Library Cataloguing in Publication Data
A catalogue record for this book is available from the British Library.

Cover design: Heather Bowen
Design and page layout: Georgina Hills, Lydia White
Text: Christina Harrison, Gina Fullerlove
Commissioning Editor: Gina Fullerlove
Production: Georgina Hills

For information or to purchase all Kew titles please visit shop.kew.org/kewbooksonline or email publishing@kew.org

Kew's mission is to be the global resource in plant and fungal knowledge, and the world's leading botanic garden.

Kew receives half of its running costs from Government through the Department for Environment, Food and Rural Affairs (Defra). All other funding needed to support Kew's vital work comes from members, foundations, donors and commercial activities including book sales.

Printed in Spain by GraphyCems

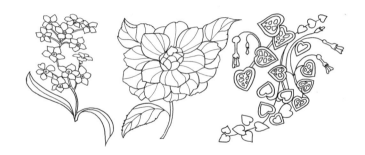

Introduction

Sue Mason is an illustrator whose art is inspired by the patterns in nature she has discovered at the Royal Botanic Gardens, Kew. She works using both living plants and Kew's unrivalled historic collection of botanical art, drawings and paintings – one of the greatest and most unique in the world.

In this book you can lose yourself in the language of flowers and take a breather in the botanical world. *Flowers of Love* will lead you into a lush garden of passionflowers, scented jasmines, bleeding hearts, through Venus' looking glass to love-in-a-puff, bridewort and the 'beautiful lady', belladonna, not to mention myrtle – the symbol of love and immortality.

Sue's training as a mathematician shows itself in the line, symmetry and structure of the illustrations she creates, that you can colour, embellish and complete in many different and satisfying ways.

On the facing page of each drawing you can also read a little about the plants – where they come from, why they are connected to love, the history, customs and folklore associated with their use. Use this to fire your colouring imagination, drawing inspiration from exotic places and ancient stories.

Finally, take time to look for Sue's many hidden hearts, colour them in or leave them for others to discover, and enjoy making this book your own.

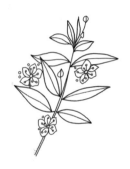

Myrtle

Myrtus communis

Sacred to the Greek goddess Aphrodite, the myrtle was a symbol of love and immortality. In Ancient Rome it was associated with Venus, and brides would bathe in myrtle-scented waters when preparing for their wedding day.

Even today there is a tradition of having myrtle in a wedding bouquet. Queen Victoria reportedly planted a myrtle at Osborne House from a posy given to her by her husband's grandmother. Every royal bride since has carried myrtle taken from that plant in her bouquet.

Myrtle is common across the Mediterranean region. Its small glossy evergreen leaves are packed with a fragrant essential oil, long used in perfumes and unguents and as an antiseptic. The fragrant bowl-shaped white flowers have pom-poms of white stamens and give way to purple-black berries. The berries themselves are used as a spice in Middle Eastern cuisine and for making aromatic liqueurs such as mirto. Today, myrtle is widely cultivated as an ornamental plant and often used for creating a fragrant hedge, perfect for any romantic garden.

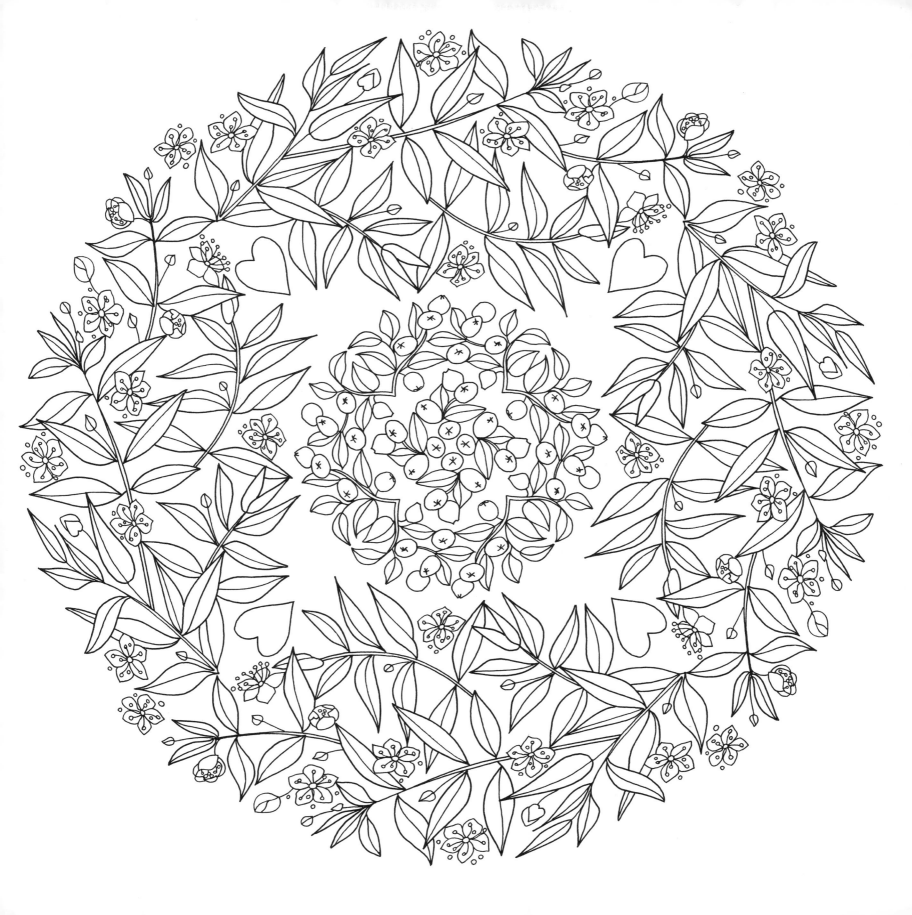

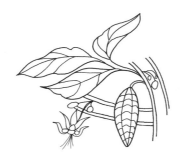

Chocolate
Theobroma cacao

Who can deny that the delectable taste of chocolate has a deeply seductive quality? Chocolate has long been associated with romance, and is the gift of choice between lovers around the world.

Its delicious properties were discovered over 2,000 years ago by the Olmec people of Mexico and Guatemala. They created cacao plantations around 400 BC and by 250 AD the Mayans were depicting cacao in their art. A chocolate drink was widely enjoyed in Mayan and Aztec culture, mainly at marriage ceremonies and religious rituals. They knew it to be a stimulant and used it as an aphrodisiac. Their original recipes included flavourings such as vanilla, chilli, achiote, herbs and honey. Spanish explorers brought the beans home and by the mid 1600s a sweetened version of the original drink was popular across Europe.

Chocolate is more than just a delicacy; evidence suggests that eating a small amount of dark chocolate every day can have a moderate effect on lowering blood pressure. But, while it is thought that the natural compounds in cacao contribute to a sense of wellbeing, it's unfortunately not guaranteed to help your love life.

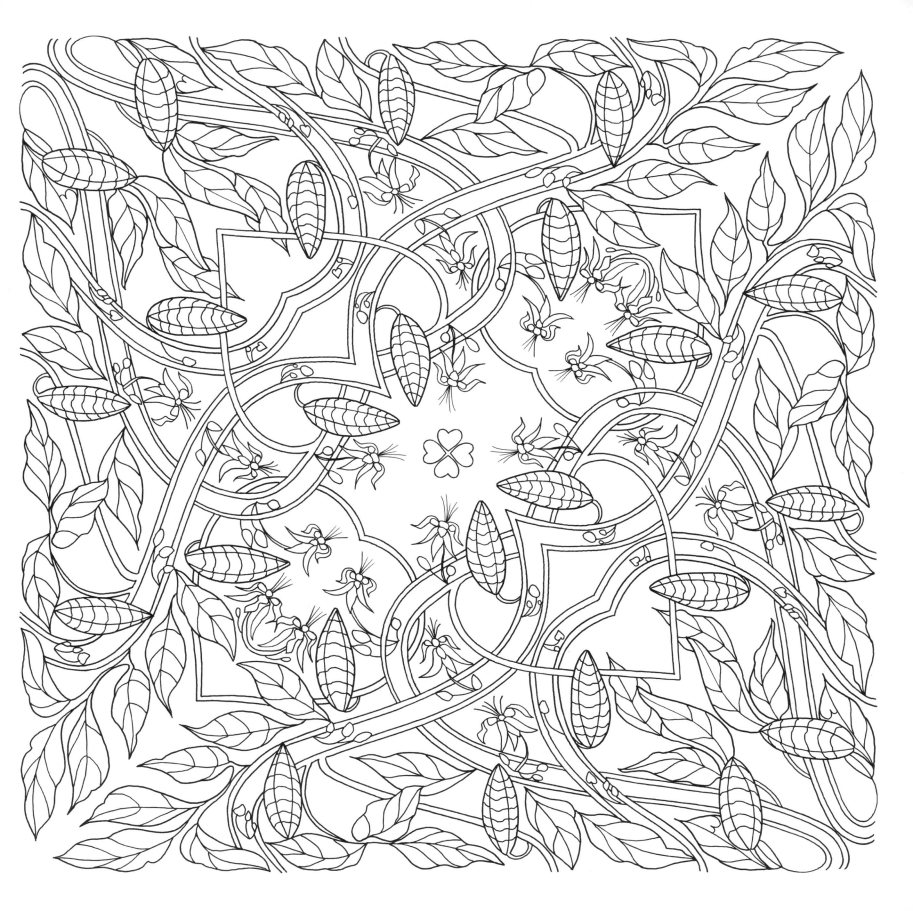

Love-lies-bleeding
Amaranthus caudatus

Dripping with tassels of crimson flowers you can easily see how this plant came by its common name. Its Latin name, *Amaranthus,* derives from the Greek words for 'unfading flower', which is apt as they can be dried to make very long-lasting cut flowers. Amaranths have a history of use for decoration, and were used by the Aztecs during festivals, while also being widely eaten in their culture.

For thousands of years, the attractive amaranth has been grown for its edible seeds. It was cultivated in ancient Mexico, Guatemala and Peru as a source of protein, and can easily be ground into flour for use in baking. The 'grains' can also be popped like corn kernels, and used for making flatbreads, biscuits, pancakes and even drinks. The leaves resemble spinach and the roots are also nutritious, and are popular in Asian cuisine. In India, amaranth is known as 'king seed' and the popped grains are mixed with honey to make a sweet. Many people think the amaranth is the grain of the future due to its many beneficial qualities.

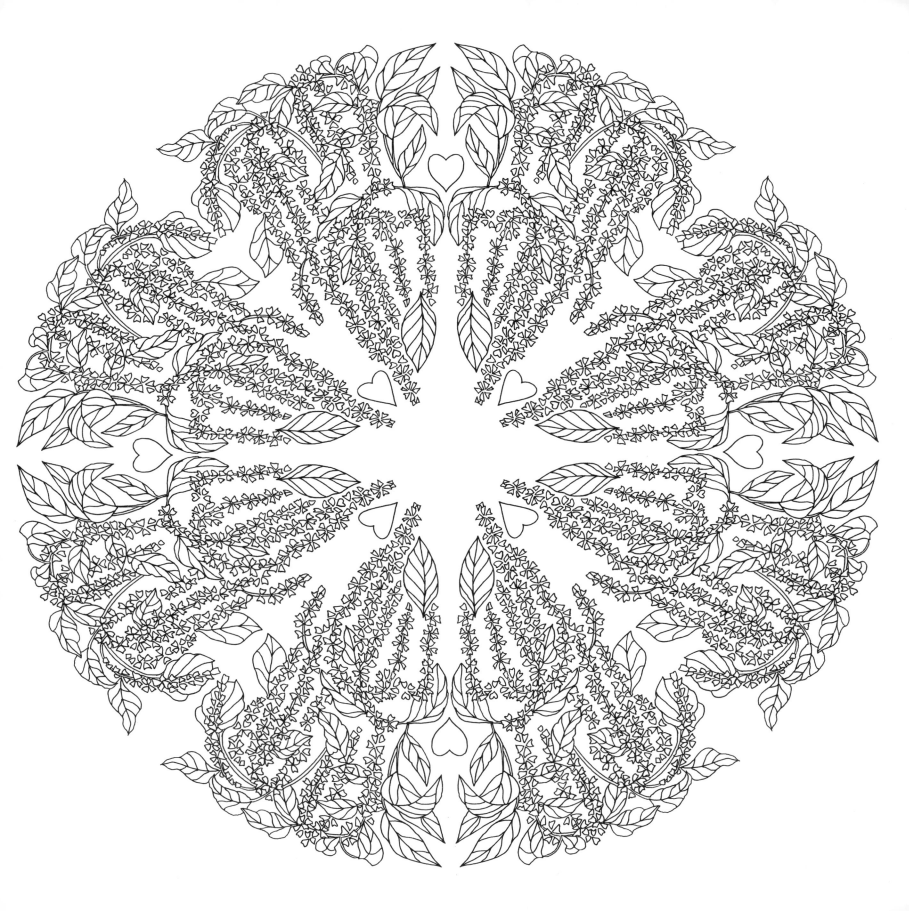

Heartsease
Viola tricolor

One of the prettiest wildflowers you will see, with petals of lavender-blue, yellow and white, heartsease is a plant with many common names – including heart's delight, come and cuddle me, Jack jump up and kiss me, love in idleness and tickle my fancy! These names crop up in surprising places such as in William Shakespeare's *A Midsummer Night's Dream* where the King of the Fairies, Oberon, places the juice of heartsease on the sleeping eyelids of his queen, Titania, to make her dote on the first creature she sees when waking.

The flowers of this charming little plant are edible and can be used to adorn summer salads, while yellow, green and blue-green dyes can be obtained from the flowers. Heartsease has a long history of being used in herbal and folk medicine. It features in many old herbals including John Gerard's of 1597, who claimed that infusions were good for bronchial complaints, itching skin, fevers and epilepsy. It has been researched for both expectorant and diuretic properties, and extracts have been found to have some anti-microbial and anti-inflammatory properties.

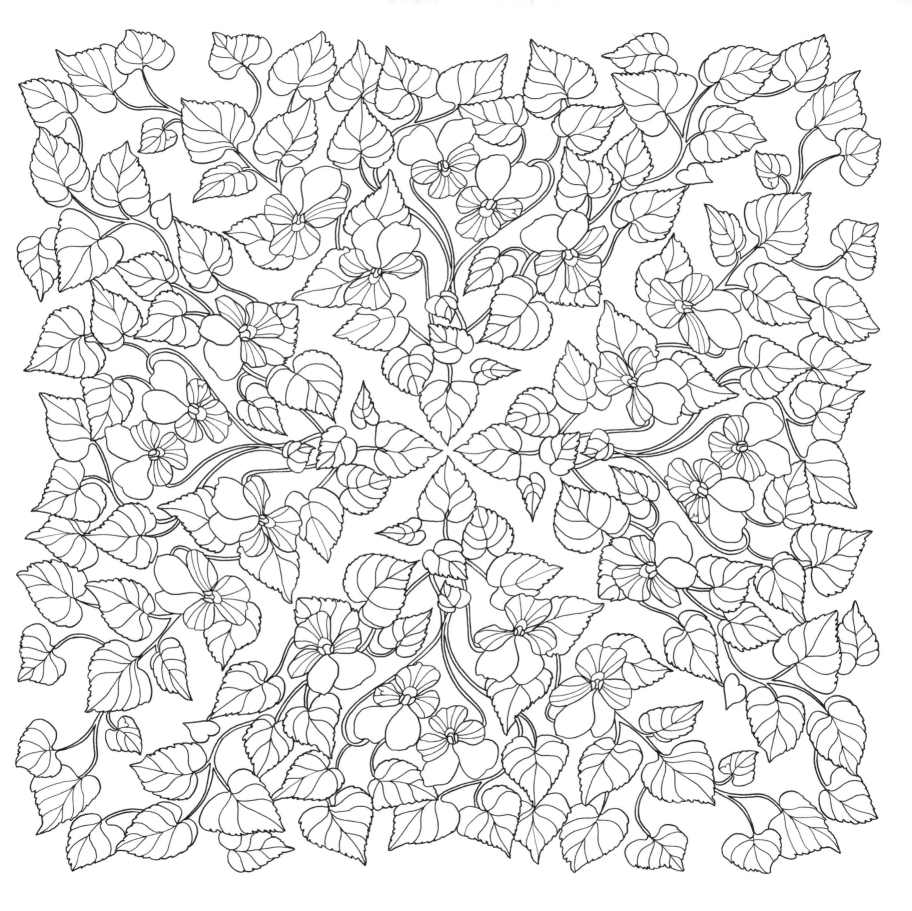

Passionflower
Passiflora caerulea

Exotic and flamboyant, passionflowers are some of the most stunning climbing plants that we can grow in our gardens. *Passiflora caerulea* is the hardiest of the 500-plus species of passionflower. It is also the only one in Britain that will reliably produce the famous orange globular fruits each autumn.

These intricately-flowered climbers quickly became popular when they were brought from the tropical forests of South and Central America to Europe in the early 1600s. Spanish priests saw them as a symbol of the Passion of Christ, and gave them their common name.

Passionflowers have long been used in folk medicine as a diuretic, analgesic, anti-spasmodic and sedative, and some have been used in teas for treating stress, but as many parts of the plant contain a source of cyanide their herbal use is not to be recommended. New species of *Passiflora* are still being discovered; in 2009 scientists from Kew found a new red-flowered species in the forests of the Brazilian Amazon, which they named *Passiflora cristalina*.

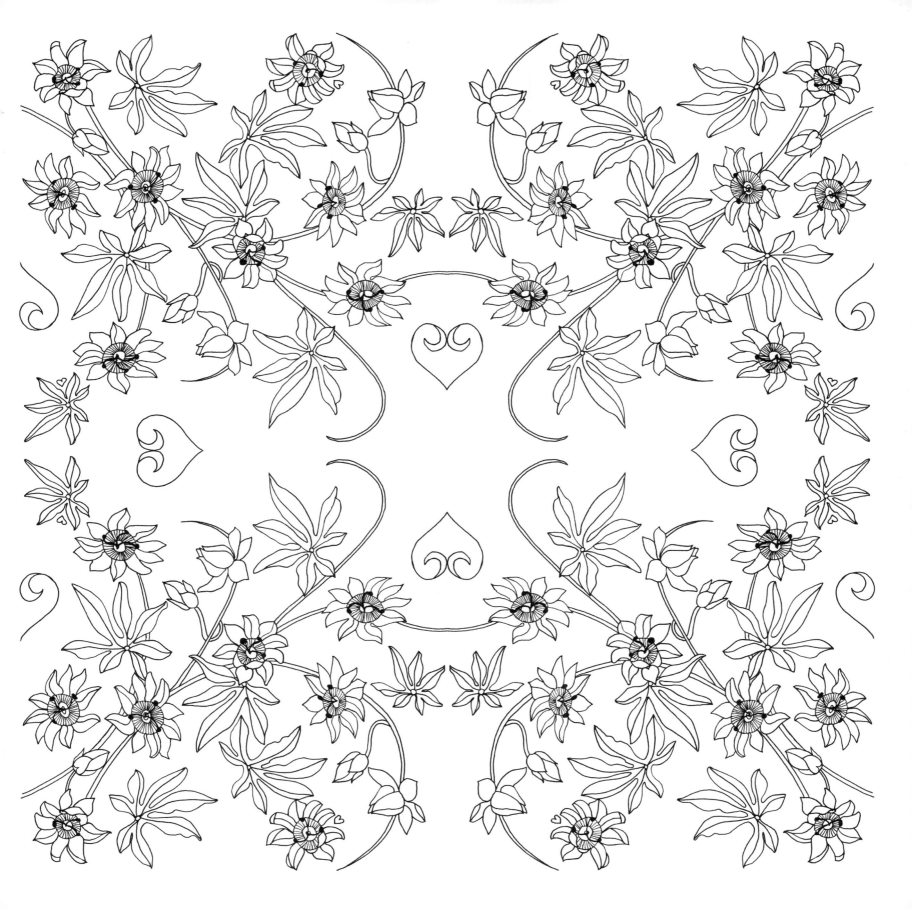

Love apple (tomato)
Solanum lycopersicum

When the tomato first arrived on British shores from Mexico in the 1500s, it was thought to be highly poisonous as it looked similar to its relative the deadly nightshade. The fruits were nicknamed 'golden apples' because the first arrivals were large and yellow in colour. Their popularity was slow to spread throughout Europe and many people simply grew them as ornamental plants.

In the 1600s however, some people tried to give the tomato a reputation as an aphrodisiac and nicknamed it the 'love apple' instead. Most were not convinced and it was not until the 1800s that tomatoes began to be widely eaten.

While herbalists of the past experimented with medicinal uses for tomatoes, today we know that they are a great ingredient in a healthy diet. Through years of breeding, their flavour and nutrition has increased, so that now they are packed with anti-oxidants and vitamins. The lycopene found in tomatoes is thought to help reduce the risk of certain cancers, while they are also thought to help keep your heart healthy. Perhaps they are 'love apples' after all.

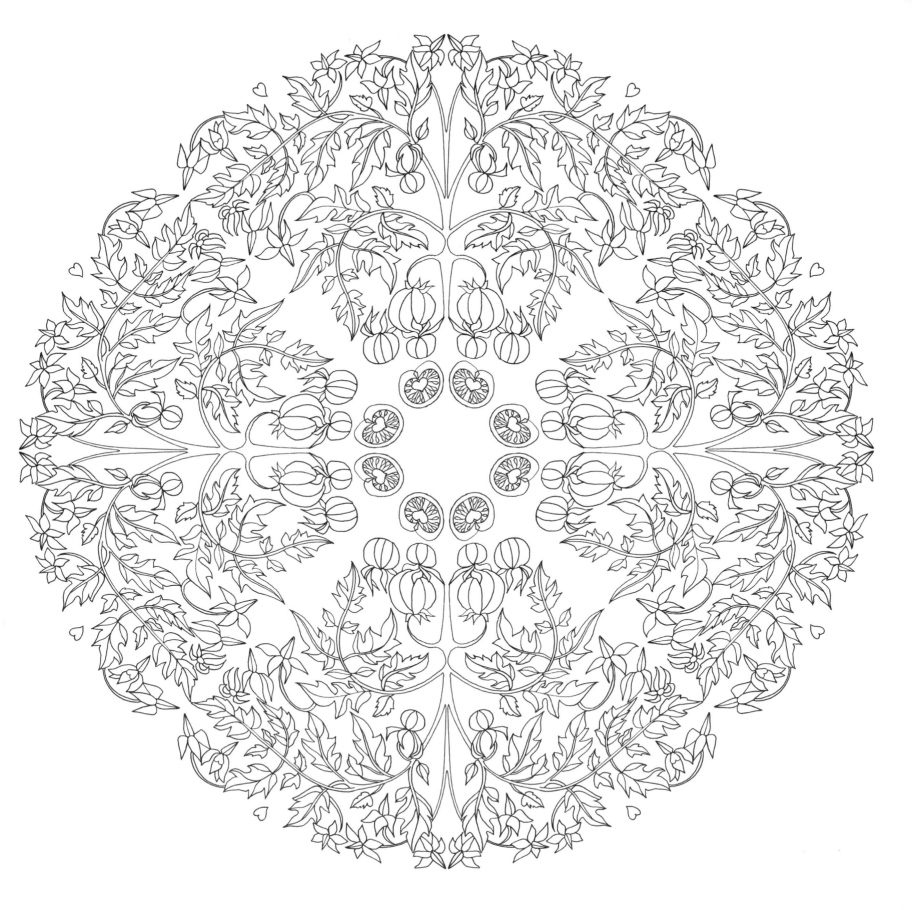

Love-in-a-mist
Nigella damascena

A favourite of cottage gardeners, and admired for its intricate feathery foliage and delicate flowers, love-in-a-mist is a widely grown annual plant from the Mediterranean. Its common name is easy to understand when you see its lacy romantic appearance.

It is not just pretty to look at however – its essential oil is valued by perfumers, who blend the sweet honey-like scent with floral notes to create heavenly aromas. The oil is also used to perfume lipsticks, so you could be wearing *Nigella* without even knowing it. The flowers are a beautiful component in bouquets, and the flowers and seedheads can also be dried for use in long-lasting arrangements.

The small black seeds of its close relative *Nigella sativa* are a culinary spice known as black cumin or fennel flower, which is used in a wide variety of dishes, in confectionery and for flavouring wines.

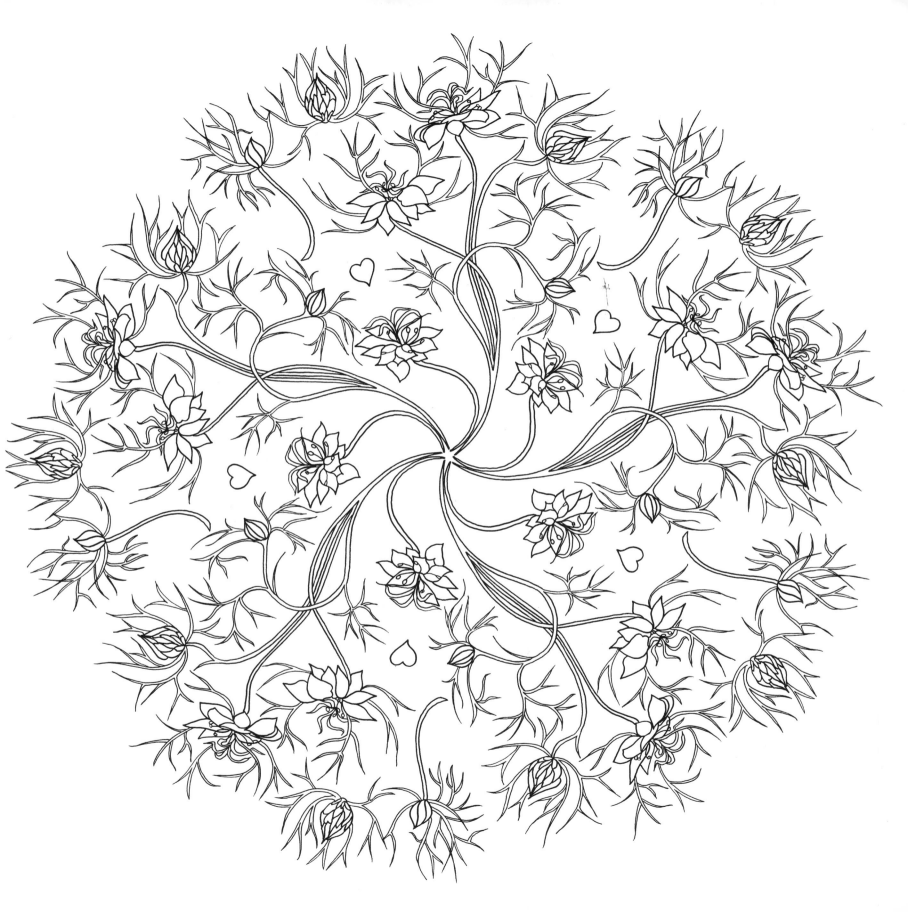

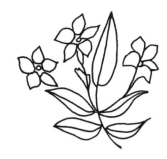

Arabian and poet's jasmine
Jasminum sambac and *J. officinale*

The sensual scent of jasmine symbolises femininity. The ancient Egyptians and Romans both used jasmine as an exotic perfume, while many religions have a tradition of using it in offerings to their gods. Jasmine is significant in The Language of Flowers, popular in Victorian times, where it symbolised grace, elegance and attachment.

Arabian jasmine is widely grown throughout the tropics, where it is used in both perfume and tea. It is one of the best sources of jasmine oil – which is very expensive as it requires so many flowers to make. The flower buds are harvested early in the morning to extract the most oil.

In the Philippines, jasmine garlands are given to honoured visitors as well as being used on special occasions such as weddings where they represent eternal love. In Indonesia it is a sacred flower, symbolising purity and grace and is used to adorn a bride's hair.

In aromatherapy, jasmine oil calms and lifts the spirit. It is also highly valued by gardeners across the temperate world for its fragrance on warm summer evenings.

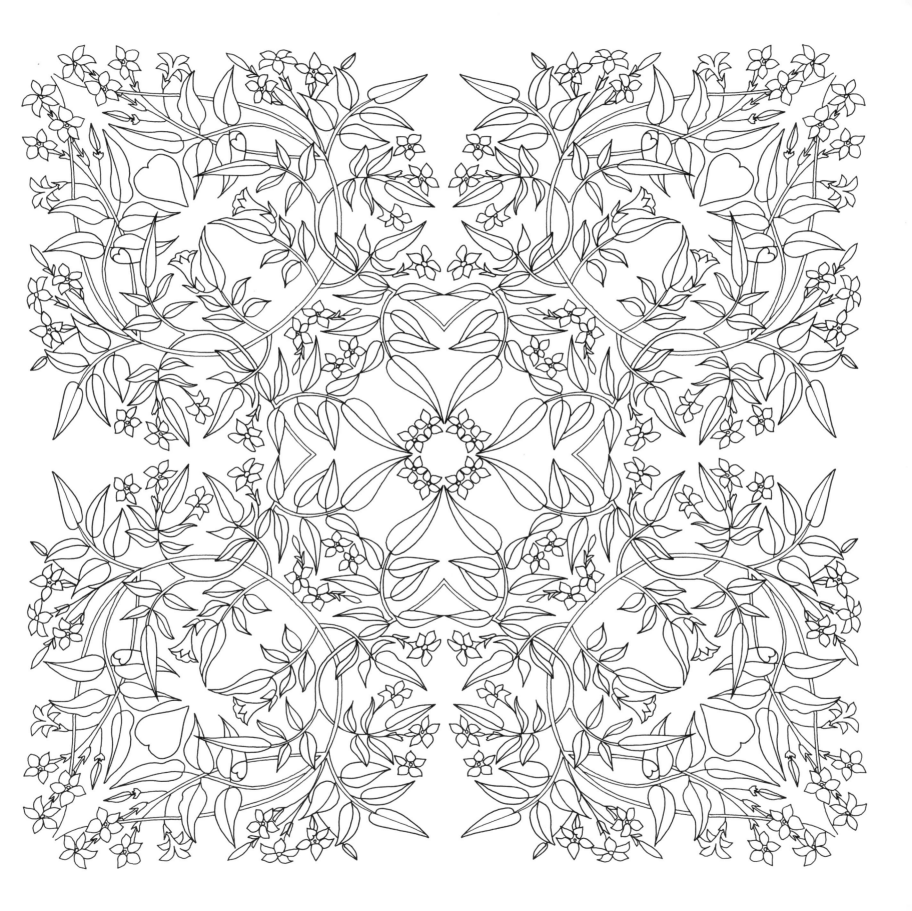

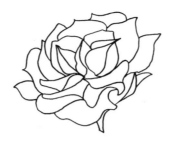

Sweetheart rose

Rosa

The true floral symbol of love, the rose has been deeply embedded in the culture of romance since the time of the ancient Greeks and Romans. They associated it with the goddesses of love – Aphrodite and Venus, and called it the 'queen of flowers'. Roses have long held our affection and have been the flower of choice at weddings for hundreds of years. Today, they are the quintessential Valentine's gift and their beauty and fragrance help us to express our love for each other.

It is not just the flowers that we admire – we use roses in perfumes, cosmetics, cooking and confectionery, medicines and in all manner of rituals and ceremonies. They have also been given aphrodisiac properties. Roses appear in our art, literature and poetry, and are one of our most popular garden plants: their beauty pervades our lives.

Sweetheart roses or petite roses are traditionally used for bouquets to give when dating, where dozens of stems are arranged in a mix of colours for the maximum impact on the lucky recipient.

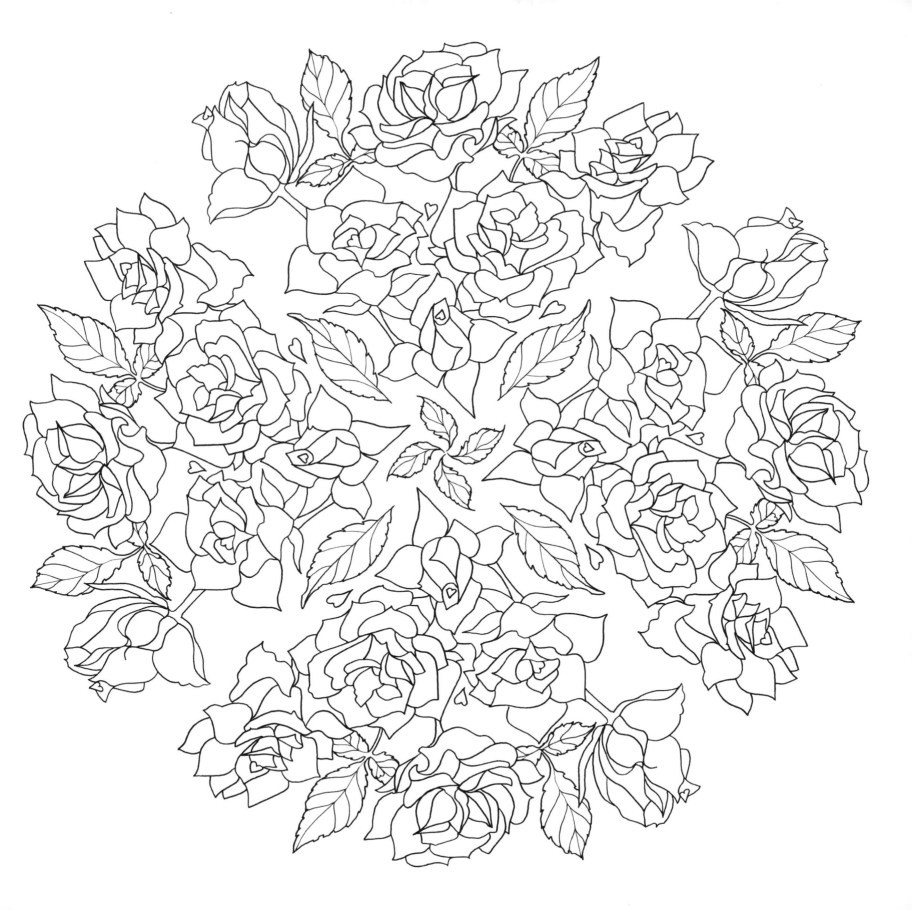

Bridal wreath

Spiraea x *vanhouttei* and 'Arguta'

What bride doesn't want to surround herself with flowers? Perhaps this is why so many flowers have wedding connections. The perfect sprays of tiny white blooms on bridal wreath would be perfect for an unusual headdress or bouquet at a late spring wedding.

Bridal wreath is a common name shared by at least two spiraeas. They are popular with gardeners as they are so generous with their flower displays. These smallish shrubs have gracefully arching stems laden with white blossom each spring, which has also led to another of their common names – May foam. The cascades of flowers are reminiscent of bridal veils and well as decadent full-length bouquets.

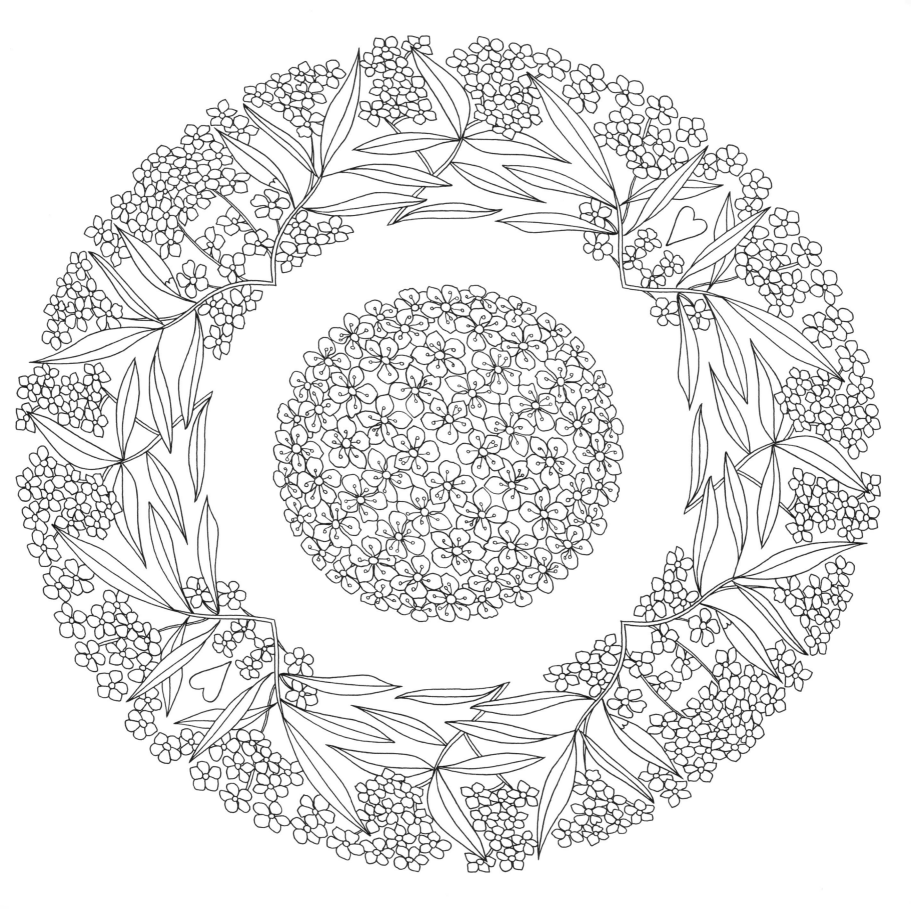

Pomegranate
Punica granatum

The sweet and juicy pomegranate is surrounded by legend. Their stunning ruby-red flesh made them a powerful symbol of life and abundance. In Greek mythology, the goddess Persephone was kidnapped by Hades, the god of the underworld. Her mother, Demeter, goddess of the harvest, mourned for her and all crops and plants on Earth ceased to grow. Zeus commanded Persephone's return, but as she had eaten six pomegranate seeds while in the underworld she was condemned to spend several months each year with Hades. This was the Greeks' explanation for the seasons as the return of Persephone meant the beginning of spring. Today, the pomegranate still has strong symbolism in Greek culture. On important religious days pomegranate dishes are served and the fruits given as gifts. At Greek weddings it is traditional to break one on the ground.

Many authors have used the symbolism of the pomegranate, including William Shakespeare in *Romeo and Juliet*, where the red colour of its flowers and fruit helps relay their passion. Pomegranates also represent fertility and plenty in the Christian, Muslim and Jewish religions.

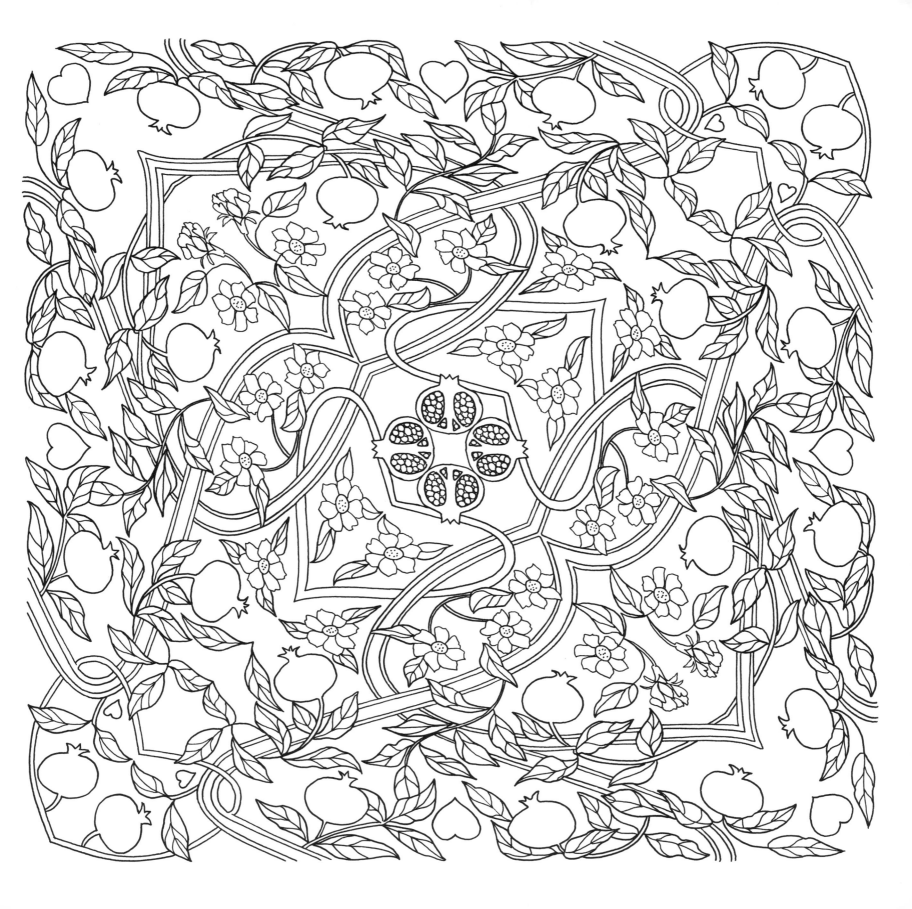

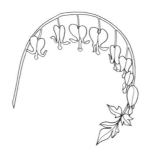

Bleeding heart
Lamprocapnos spectabilis

This unusual and charming flower is popular with gardeners and florists. Its pink heart-shaped blooms appear in spring, hanging delicately in rows on long arching stems. The common name comes from the flower's shape – a heart that appears to be bleeding a white droplet, but turn the flower upside down and you can also easily see where it gets another of its common names – lady in a bath!

The plump pink and white blooms can be used as cut flowers and look wonderful when paired with textural foliage such as ferns and hosta leaves. They would be perfect for Valentine's Day bouquets – if only they flowered in time.

The first specimens of this perennial plant were brought to Britain from eastern Asia in the 1840s by the plant hunter Robert Fortune.

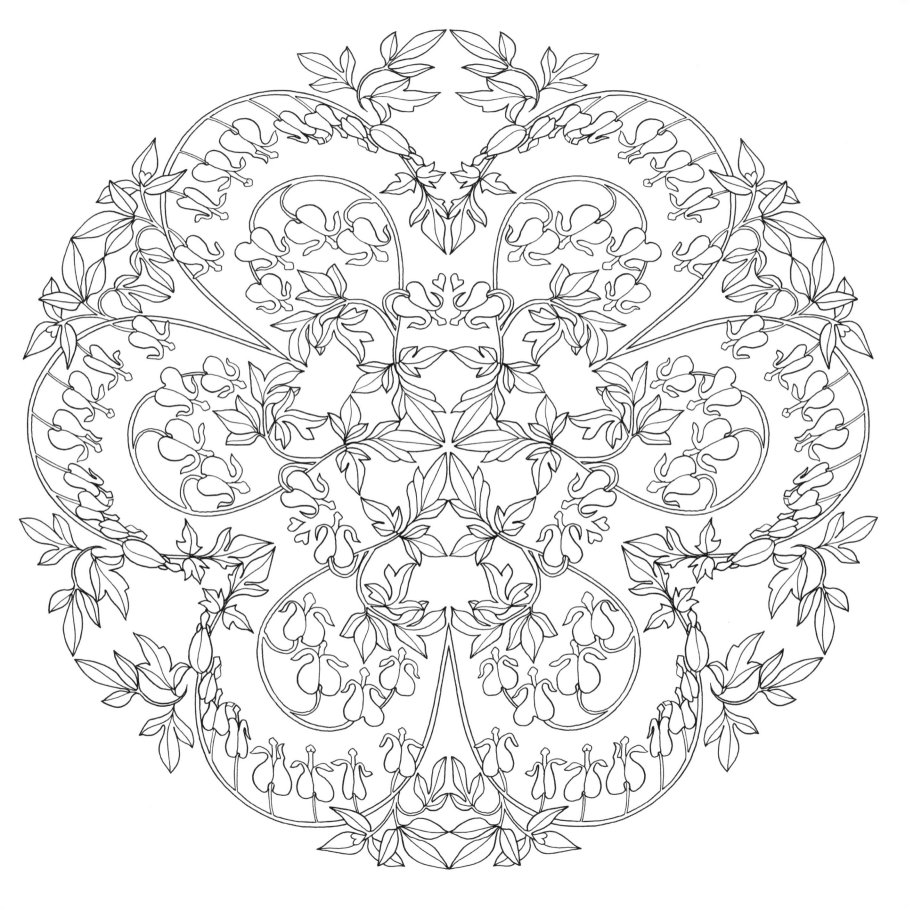

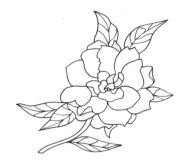

Cape jasmine
Gardenia jasminoides 'First Love'

The showy double flowers of this stunning gardenia have a heavenly perfume that drifts luxuriously on the breeze. The pure-white waxy blooms emerge above the glossy leaves in spring or early summer and if pollinated, the flowers transform into small orange oval fruits.

This species has been cultivated in China for many centuries, where it has been used to scent tea, and as a source of yellow dye for food, drinks and clothing. The flowers are commonly used in garlands in Polynesia, where they are given as gifts of welcome or as symbols of affection. The essential oil found in the flowers is valued for use in exotic perfumes, while the fruits are used to treat flu and colds in modern Chinese herbalism.

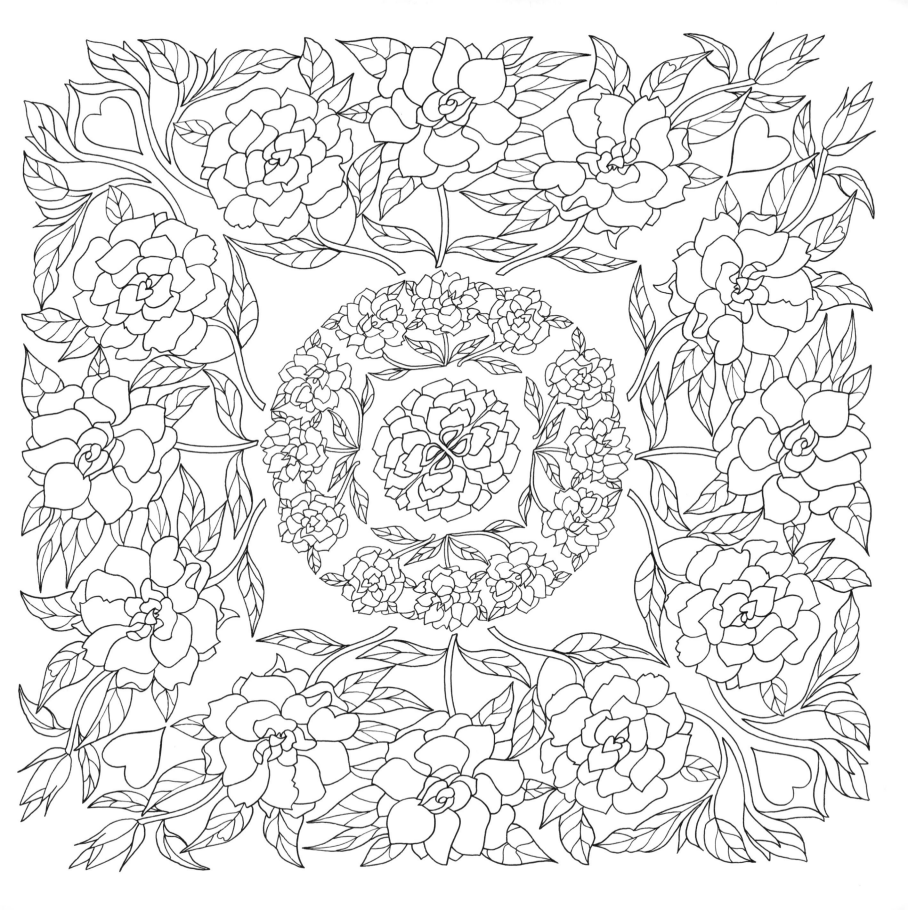

Goldenheart ivy
Hedera helix 'Goldheart'

Ivy is a familiar evergreen in our landscape and gardens. It is one of the choice plants for making Christmas garlands, wreaths and kissing boughs. Variegated varieties such as 'Goldheart' are perfect for helping to brighten our homes in the winter months.

Using ivy for decoration dates back thousands of years. The Greek god Bacchus wore a wreath of ivy to ward off drunkenness, while the Romans saw its twining stems as a symbol of fidelity. To the ancient British Celts evergreens such as ivy were symbolic of eternity and rebirth, and they would bring ivy, holly and mistletoe indoors during winter to ward off ill fortune in the dark cold months. It was also used by their druids in ceremonies.

In Ireland, ivy was once used for love spells, where young girls would place leaves under their pillows at Samhain (Halloween) saying: *Nine ivy leaves I place under my head, To dream of the living and not of the dead, To dream of the man I am going to wed, To see him tonight at the foot of my bed.*

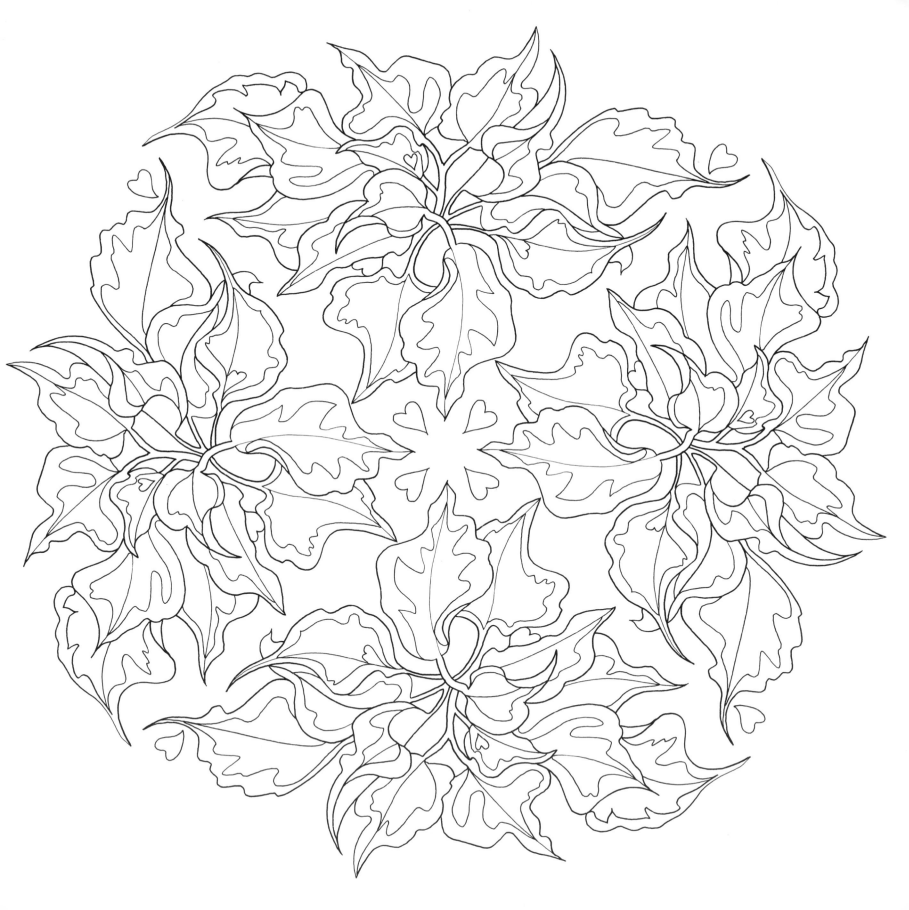

Venus' looking glass
Legousia speculum-veneris

This dainty little annual plant grows in sunny, sandy parts of the Mediterranean. The bright violet-blue flowers appear in profusion on its many branched stems. Some say the unusual common name comes from the long 'calyx' that holds the base of the flower, which resembles a mirror handle. Others say it is down to the shining oval fruits that grow inside the seed capsule. Perhaps those who named it thought it beautiful enough for Venus to gaze at herself in, and this delicate plant is certainly attractive. They are perfect flowers for growing in a wildflower patch or annual border to attract beneficial insects to your garden.

Another annual plant called Venus' looking glass is native to North and South America, and can be found as a wildflower on prairies and in woodland glades, along waterways as well as in a variety of open areas. This is *Triodonis perfoliata*, and is also thought to have been given its common name due to its shiny mirror-like seeds.

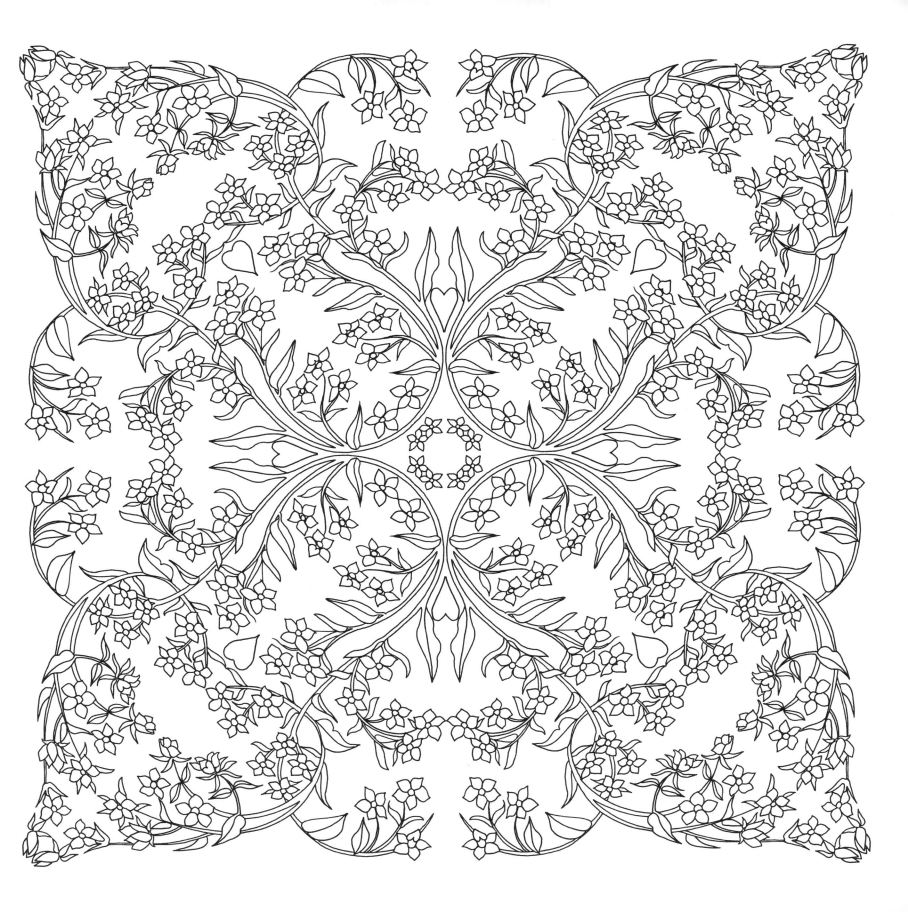

Bridewort
Filipendula ulmaria

A delightful froth of creamy-white flowers, this grassland herb is also known as meadowsweet, queen of the meadow and kiss-me-quick. It has a history of being used to flavour meads and ales and also as a strewing herb for earthen floors. It is known as bridewort because it was strewn in churches on wedding days to release a sweet pleasant scent as the bride entered; it was also added to bridal garlands.

This plant is a familiar sight along streams and rivers, and in damp meadows. Its fern-like foliage and flowers are easily recognisable. It has been used to make herbal teas for coughs and colds, as well as in herbal remedies for pain relief and aching joints. The flowers can be gathered and dried and used in jams or simply as a pot pourri.

The whole herb has uses, but it is famous for being the plant that salicylic acid was first isolated from in 1839. This substance was later synthesized as aspirin, a name which came from its old Latin name – *Spiraea ulmaria*.

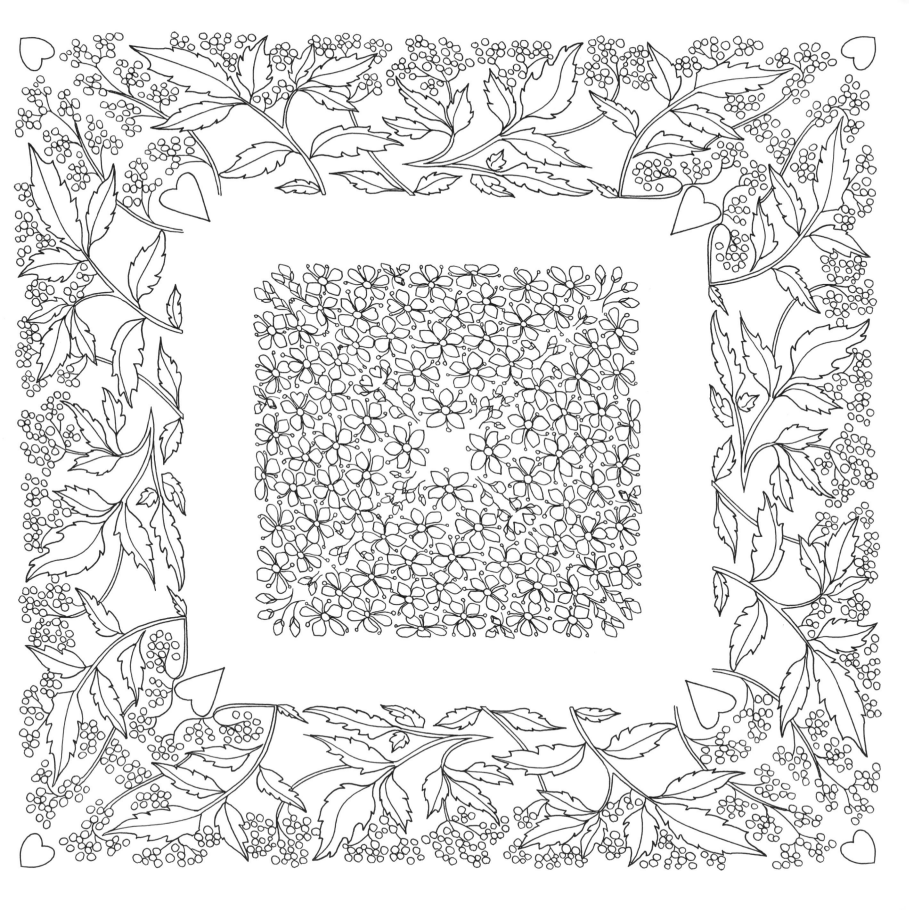

Belladonna
Atropa belladonna

The elegant common name for this plant is belladonna, but you may know it as deadly nightshade, which is much more appropriate. The name belladonna (Italian for 'beautiful lady') comes from its historic use as an eye drop to dilate the pupils and make women appear more attractive to their suitors. The plant is toxic however, so no matter how much more seductive it makes you look, this is never advisable.

The name *Atropa* comes from the Greek goddess Atropos – one of the Fates, who, along with Clotho and Lachesis, determined your destiny by weaving the threads of life together. Atropos was the cutter of the thread!

In folklore belladonna was notoriously used by witches to help them 'fly'. Taken with other plants containing psychoactive compounds it led to hallucinations including the sensation of flying.

Belladonna has been used for pain relief and in many herbal tinctures, but the roots, foliage and glossy black berries are extremely toxic. It is in fact one of the most poisonous plants found growing wild in Europe, and has been a favourite of jilted lovers and assassins throughout history.

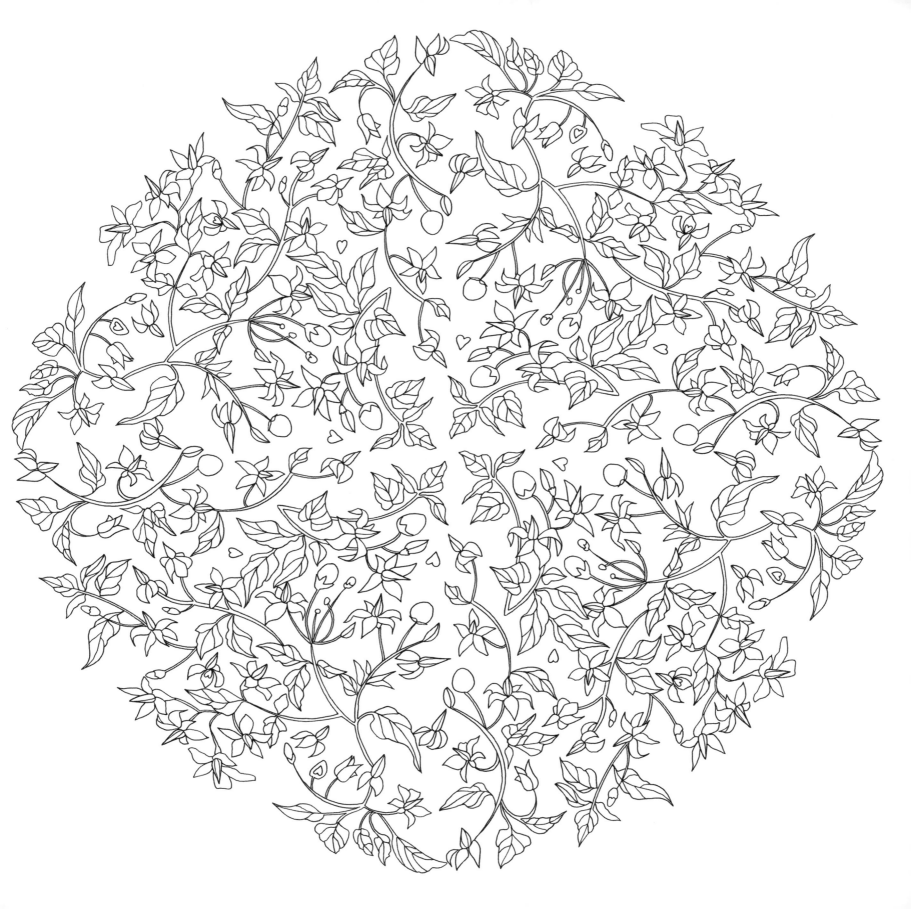

Sweetheart vine
Ceropegia woodii

Due to its beautiful heart-shaped leaves this delicate little trailing vine has earned a range of romantic names including chain of hearts, hearts on a string, hearts entangled and sweetheart vine. It is perhaps the perfect botanical gift for a loved one.

This plant is native to southern Africa, where it was discovered in 1881 by botanist and plant collector John Medley Wood. In 1894 he sent a living plant to Kew where it flowered and was painted by botanical artist Matilda Smith, and then named after its discoverer.

It thrives in full sunshine, where the succulent heart-shaped leaves turn a deep shade of green traced with grey. The curious pale magenta and deep purple flowers appear in summer and last for several weeks. These distinctive blooms lure in insects with a strange scent and trap them inside to ensure they are pollinated. It is an easy to grow and rewarding houseplant, and is very forgiving of a little neglect – which is not recommended for your real sweetheart of course!

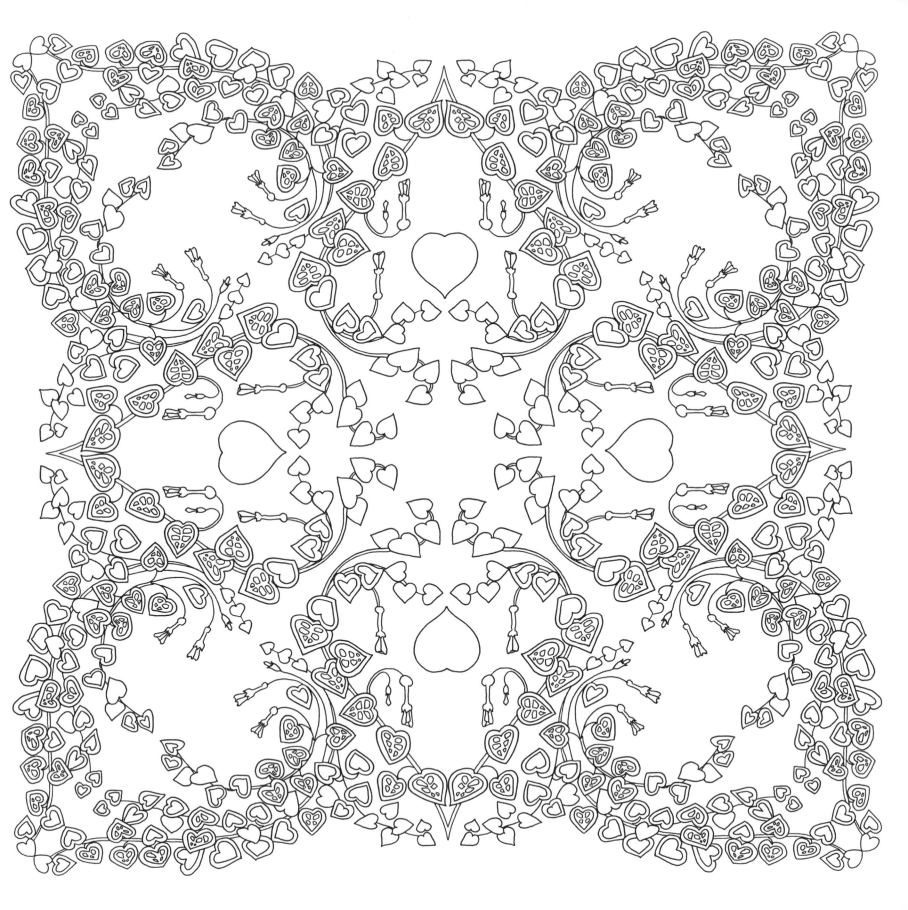

Touch-me-not 'True Love'
Impatiens walleriana

One of the world's favourite annual bedding plants, the busy lizzie or touch-me-not, began life as a native plant of the shady forests and riverbanks of east Africa. Originally it bore orange-red flowers, but you can now find busy lizzies in all manner of colours from blushing pink to dusky red and even snow white. Cultivars come with wonderfully evocative names – the one drawn here is called 'True Love' with pink-red flowers and soft green leaves. You'll see cheery busy lizzies everywhere from blousy displays in parks and gardens to containers and window boxes.

The name 'busy lizzie' refers to how long and prolifically these plants flower for, while the Latin name comes from 'impatient', referring to how quickly their seedpods explode when touched. *Impatiens walleriana* was first described by Sir Joseph Hooker, one of the most illustrious directors of the Royal Botanic Gardens, Kew, in 1867. It was beautifully painted by Kew artist Matilda Smith for *Curtis's Botanical Magazine* in 1905.

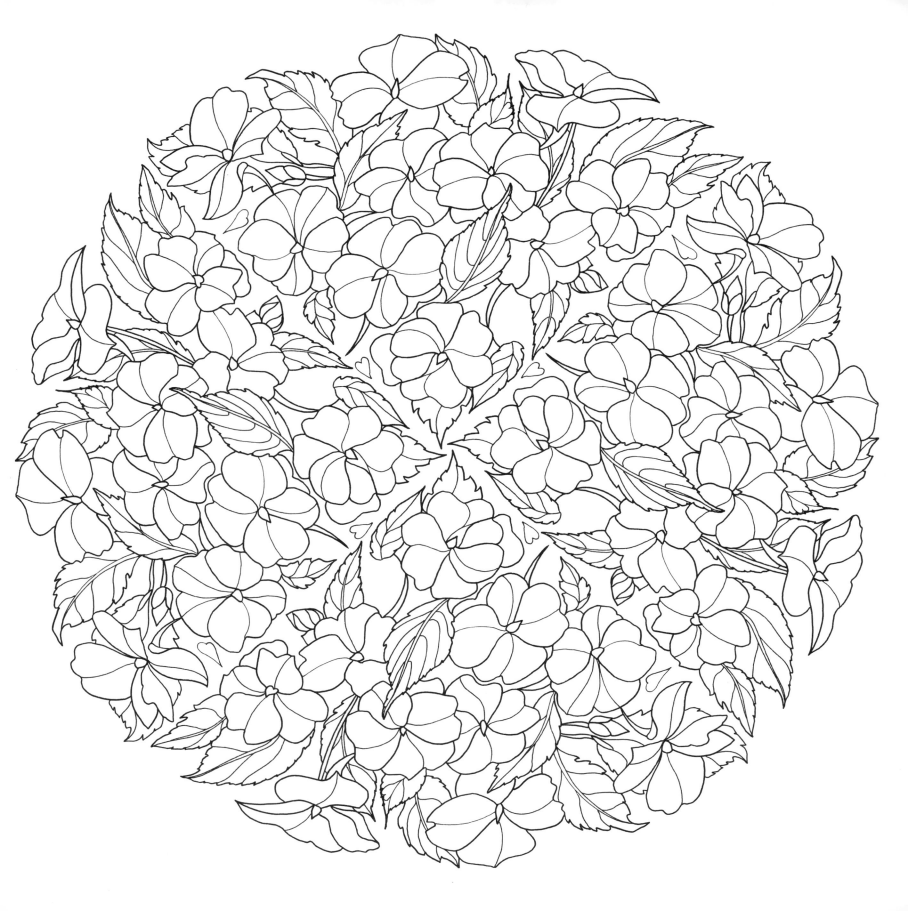

Tahitian bridal veil
Tripogandra multiflora

This pretty little plant from Central and South America was named for its profusion of delicate white flowers resembling a shimmering veil. For a bride to wear flowers at her wedding – especially a circlet of flowers or having flowers in her hair, is a tradition that goes back centuries. Many of these flowers are chosen for their fragrance as well as their beauty, such as roses, myrtle and orange blossom. Others were gathered as wildflowers to represent the season. Nearly all came to be symbolic of virtue, friendship, purity, fertility or love in a type of 'bridal folklore'. Some were even chosen to ward off evil. Today, much of this symbolism comes from the Victorian Language of Flowers, which all helps to add layers of meaning to one of life's special occasions.

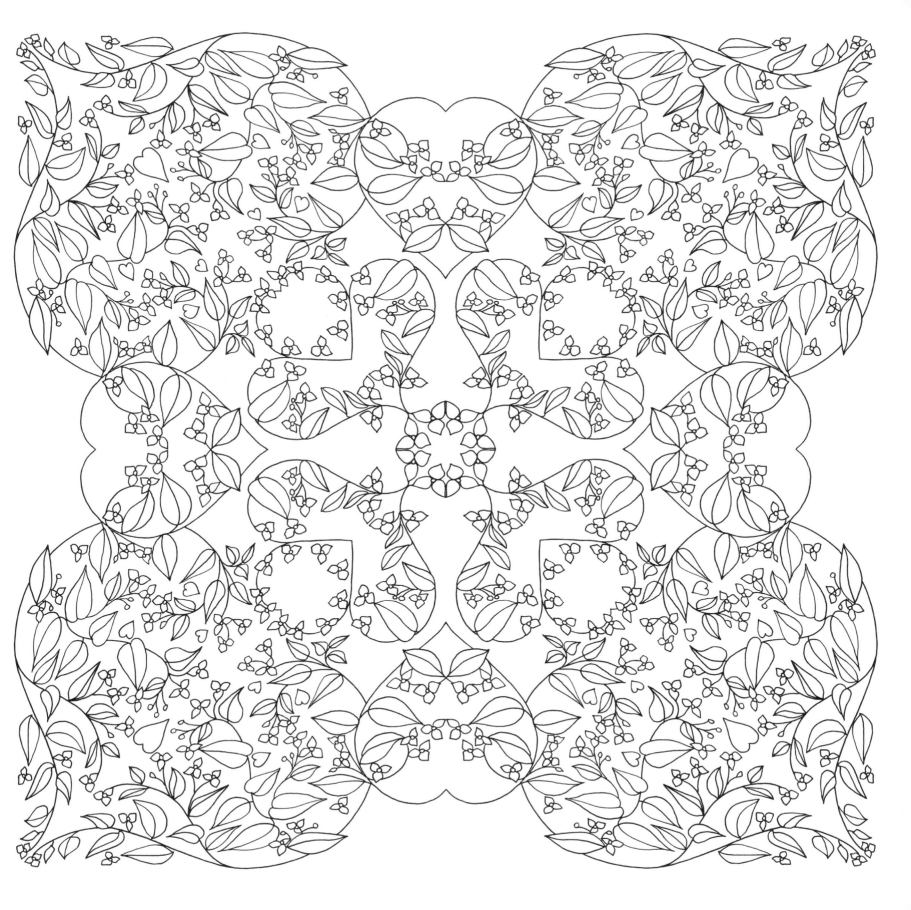

Cyclamen

Cyclamen hederifolium

Long ago the cyclamen was a favourite ingredient in love spells. Small cakes were baked using roasted cyclamen tubers and were said to cause anyone who ate them to fall violently in love with the one who made them. You can only presume that people made this association due to the beautiful heart-shaped leaves of this plant, as in reality cyclamen is a powerful purgative and eating it is extremely inadvisable!

Some believe that the cyclamen represents devotion – the plant's tuber allows it to thrive in difficult conditions, while the flower is said to symbolise true love. In the Victorian Language of Flowers, giving a gift of a cyclamen is a fond way of saying farewell.

Cyclamen hederifolium is native to the Mediterranean region. The flowers, which appear in late summer and autumn, can be a cerise pink, magenta or white. Its simple graceful form has made it a favourite with many artists since the Middle Ages.

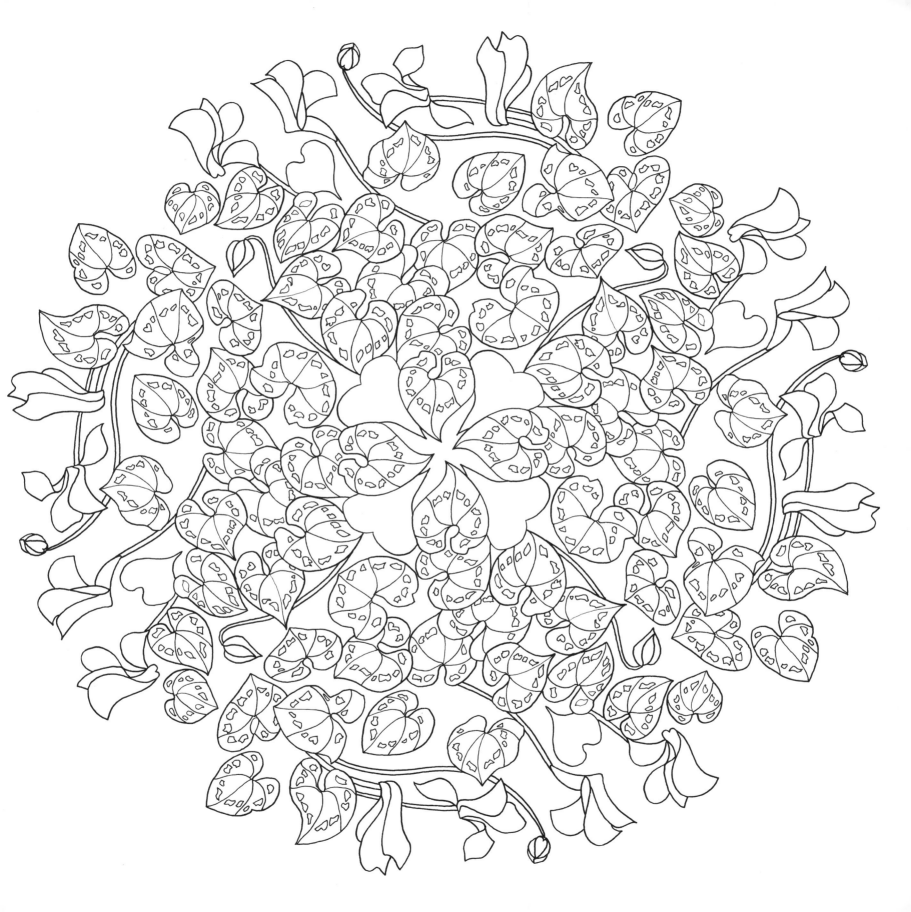

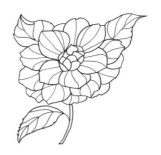

Camellia
Camellia japonica

Camellias add beauty and glamour to our gardens, flowering in some of the coldest months of the year, but they are also romantic blooms to have around. According to Chinese tradition, the perfect symmetry of a camellia flower symbolises long-lasting devotion and perfect unity. Each colour also has a different meaning – pink denotes longing, red is for passion, white is for perfection and purity.

Native to Japan and China, camellias have been cultivated for thousands of years. Their neat, symmetrical flowers come in both single and double varieties, appearing above dark green, glossy leaves. They are used in ceremonies and have come to represent the divine in Japan and faithfulness in Korea. Camellias also feature in New Year's decorations denoting wishes of good luck, prosperity and longevity.

Camellias are useful plants to have around. The young leaves of *Camellia sinensis* are used to make tea, and other species are used in traditional Chinese medicine to treat a variety of ailments from asthma to heart disease.

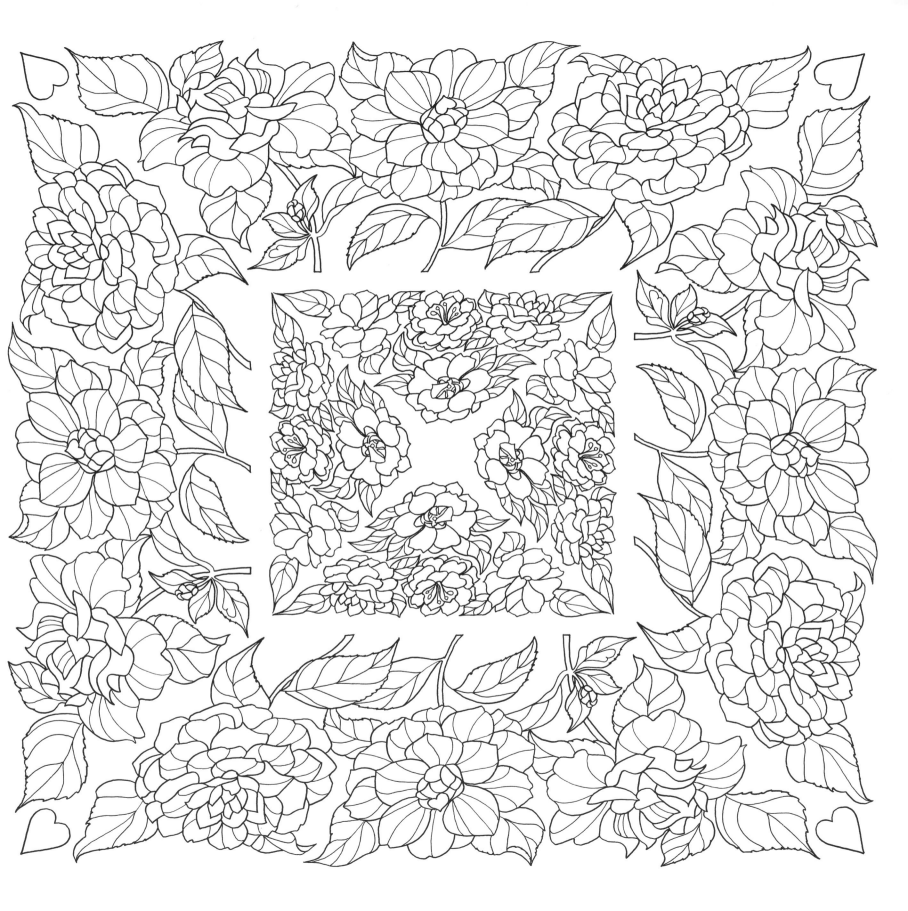

Purple heart
Tradescantia pallida 'Purpurea'

This tender perennial from eastern Mexico is commonly used as ground cover in tropical gardens, but is best known in temperate regions as an elegant evergreen houseplant. Its elongated purple leaves are at their best when grown in full sun. In summer, small baby-pink three-petalled flowers appear at the stem tips. Purple heart is a low-growing trailing plant, which looks good all year round. It is also thought to be effective at removing pollutants from the air, improving air quality indoors, meaning that as well as bringing you joy to look at, it is looking after you too!

There are several cultivars of *Tradescantia pallida*, but 'Purpurea' has an RHS Award of Garden Merit for being beautiful, reliable and easy to grow. It is easy to propagate too – you can simply pinch or cut off the ends of the shoots and pot them on, they will take root easily so be sure to share your purple heart around.

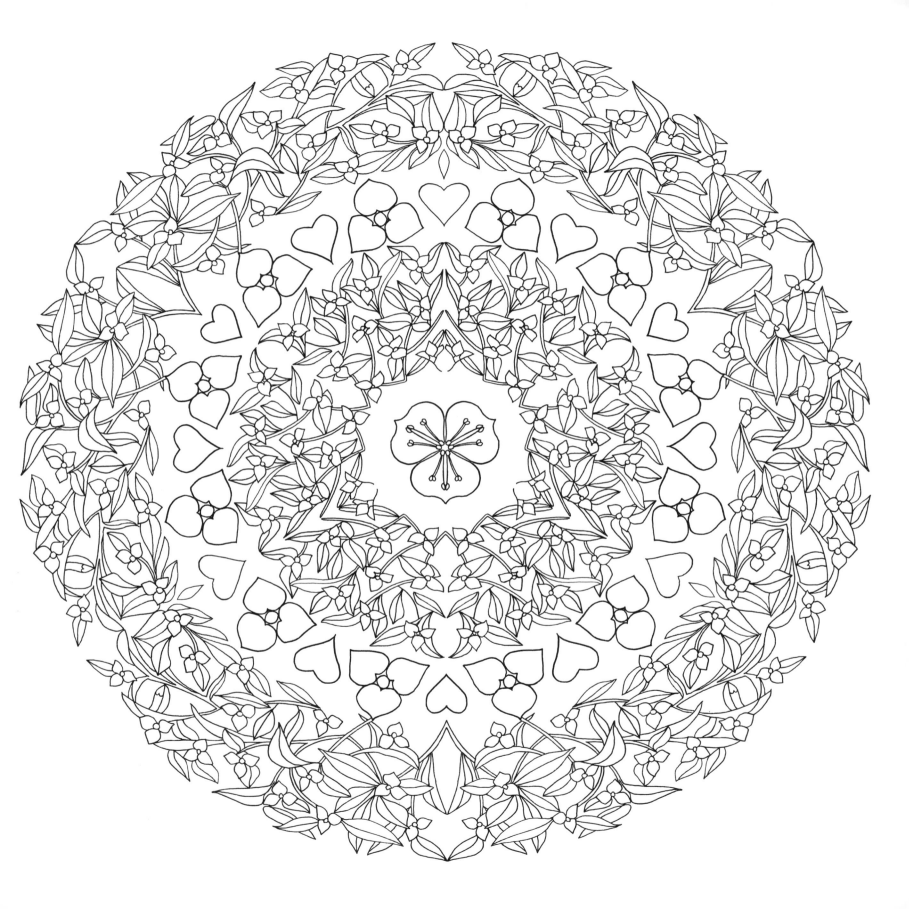

Moth orchid
Phalaenopsis

Exotic, elegant, refined, coveted. Orchids are all these things and more. They have a sculptural symmetrical beauty that catches the eye, and are surrounded with tales of adventure. Men risked all to find these botanical rarities in tropical jungles and to bring them home. They were treasured symbols of luxury and taste in the Victorian era.

Today, many orchids are still rare or even endangered, but cultivars of the moth orchid have become increasingly available for us to give as gifts on special occasions. They now come in an astonishing variety of colours, adding a touch of class to our homes.

Different cultures down the ages have assigned special powers to the orchid. Several species have been used in traditional Chinese medicine for thousands of years, while in Chinese art they were symbols of integrity and humility. However, many have associated the orchid purely with love. Dreaming of orchids denotes a desire for romance, while giving them as gifts is a symbol of your love for another.

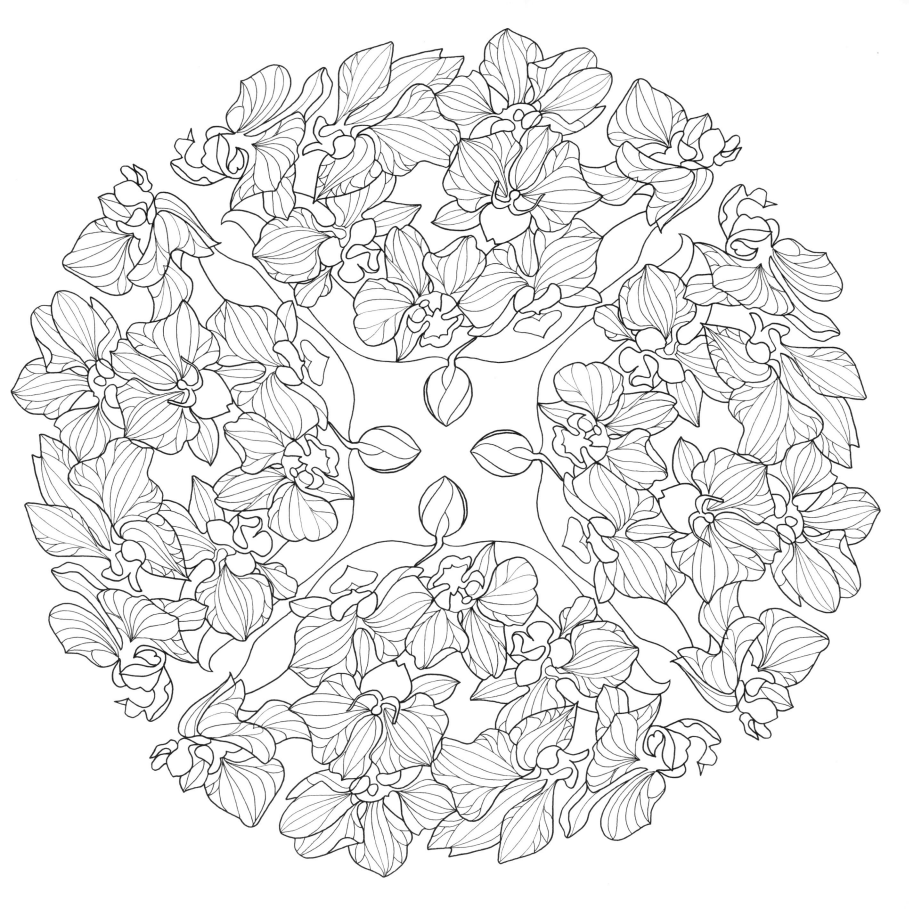

Love-in-a-puff
Cardiospermum halicacabum

The surprising and delightful golden heart-shapes on the seeds of this plant made it easy to give it such a romantic common name. Their attractive appearance means they are often used as beads in their native tropical America.

This vigorous climbing plant has tiny white flowers, which once pollinated form into inflated balloon-like fruits, each containing three perfectly round black seeds. Love-in-a-puff originally comes from tropical America, but is common across the tropics. Every part of the plant has been used in traditional medicine to treat a range of ailments from digestive disorders to ear-ache and rheumatism. It is also one of the ten sacred flowers of Kerala, India, which together are known as Dasapushpam. These are all medicinal herbs, used for decoration during festivals as well as for marriage celebrations.

Love-in-a-puff is just one of over 30,000 species that are safely stored in Kew's Millennium Seed Bank at Wakehurst in West Sussex, preserved for study and practical conservation.

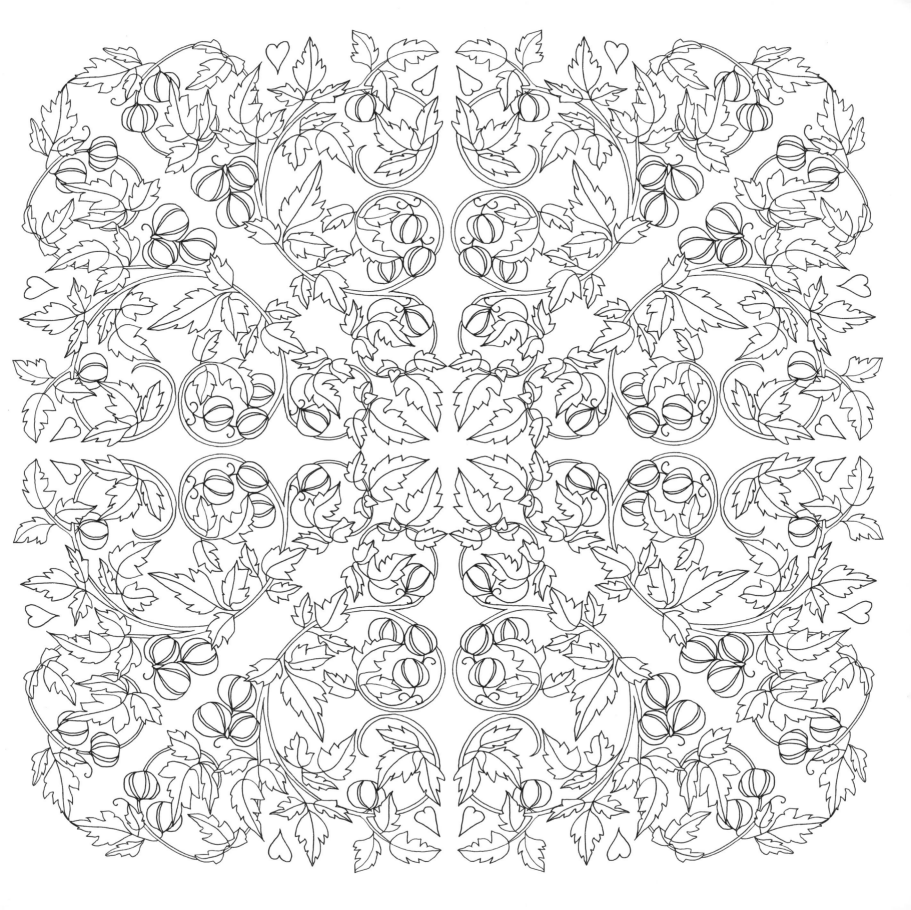

Sweet orange blossom
Citrus x *aurantium*

The white fragrant blossom of the sweet orange tree is emblematic of fruitfulness, happiness and a prosperous marriage. Stories of using orange flowers for bridal wreaths and hair decoration are thought to date back to ancient China. The custom spread and the phrase 'to gather orange blossoms' took on the meaning 'to seek a wife'. Queen Victoria popularised their use in England when she wore the flowers as a headdress at her wedding in 1840.

Oil distilled from citrus flowers and peel is an essential oil used in perfumery. It reputedly has aphrodisiac qualities as well as being an anti-depressant. The petals can be made into orange flower water for use in cooking and delicious delicately-scented desserts. In the Middle Ages oranges were a key ingredient in making pomanders – scented balls of herbs and perfumes carried to help ward off infections and bad smells. A pomander of orange and cloves, wound with a gold ribbon was also used as a cure for witchcraft. Today, these spiced orange balls are used to decorate our homes at Christmas and release their wonderful aromas.

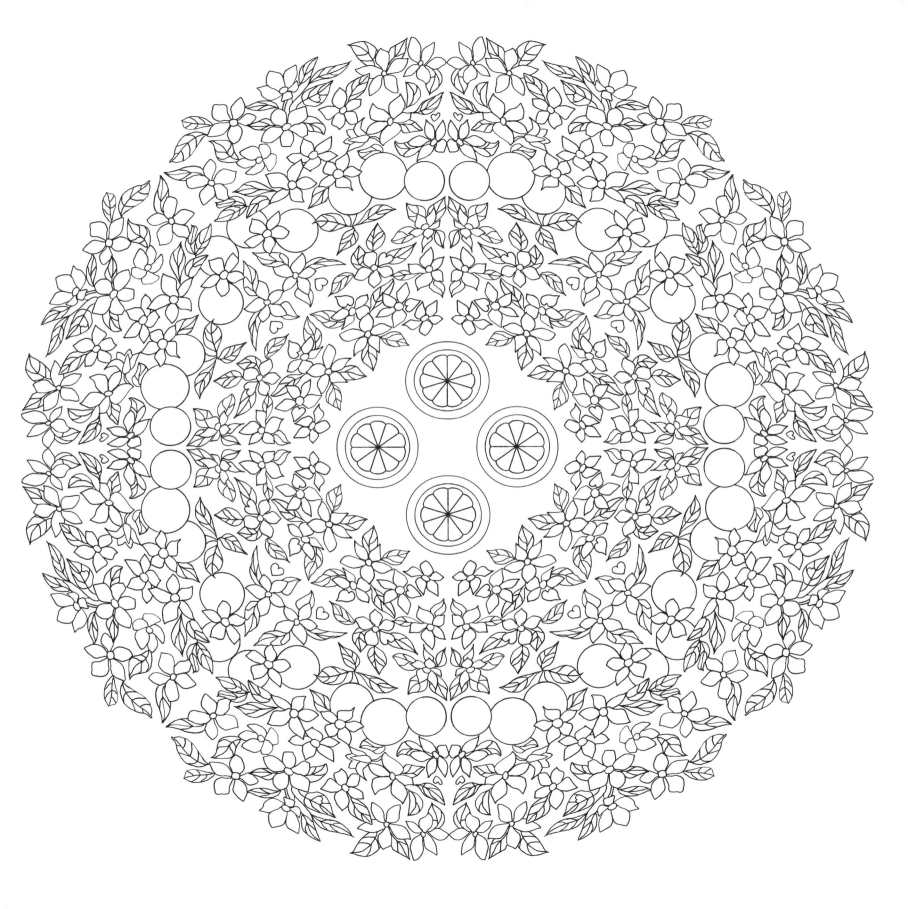

Heartbreak grass
Gelsemium elegans

While some plants can help with romance, others can cause heartbreak through tragedy. *Gelsemium elegans* is one such plant and has earned its common name 'heartbreak grass' from its use in suicides. It is not a grass however, but a twining climbing plant from South-East Asia with beautiful butter-yellow flowers. It is highly toxic due to the alkaloids it contains that are related to strychnine. Its unpleasant symptoms come on very quickly and there is no specific antidote.

Two recent high profile murder cases claimed gelsemium as the culprit. Most recently, a Russian exile was poisoned in his own home in Surrey. The cause of death was unknown until experts at Kew identified gelsemium in his body.

The effects of this plant fascinated the creator of Sherlock Holmes, Sir Arthur Conan Doyle, who experimented with small doses of heartbreak grass on himself. It had originally been prescribed to him in a small dose as a treatment for nerve pain, but he increased his doses to see exactly what the effects were, and reported his findings.

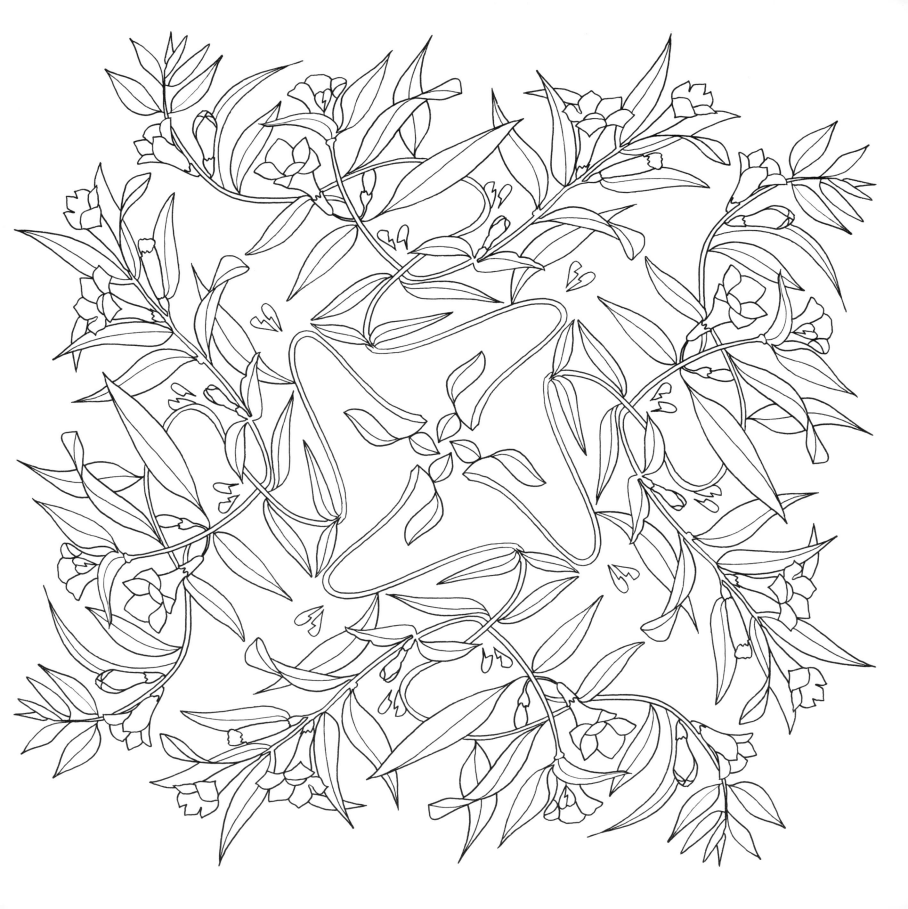

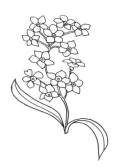

Forget-me-not

Myosotis

If ever a flower represented faithfulness and enduring love it is the dainty forget-me-not. There are many different species known by the same common name, however the water forget-me-not (*Myosotis scorpioides*) is native to Britain and has clear blue flowers with tiny yellow or white eyes, atop tall hairy stems. The flowers emerge from pale pink buds each spring, and this resilient little plant will keep flowering all through the summer.

Forget-me-nots have been symbols of love and constancy since the Middle Ages, and have appeared in many works of art and poetry since that time. They were extremely popular on Victorian Valentine cards as the classic floral messenger, while they also make an appearance in DH Lawrence's novel *Lady Chatterley's Lover*. They are the perfect little flower for creating a meaningful posy.

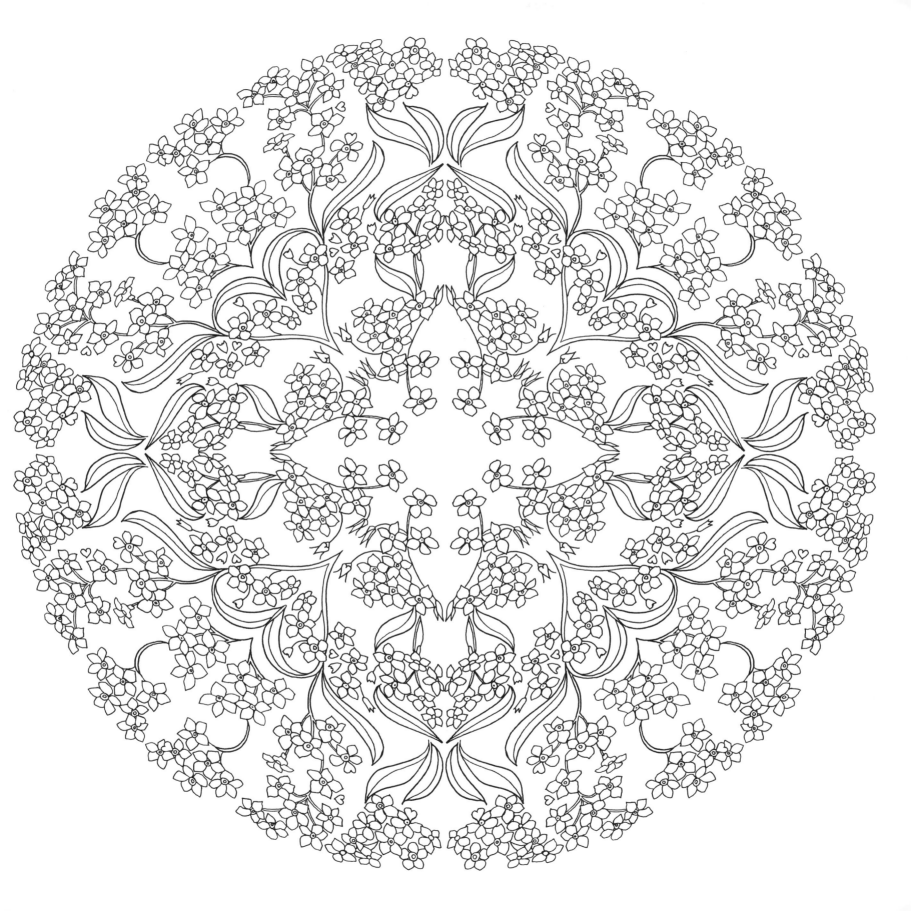

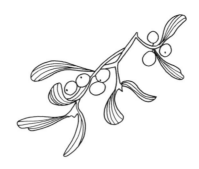

Mistletoe, kiss-and-go
Viscum album

Everyone knows the significance of mistletoe; the sight of a sprig above a doorway can bring out almost anyone's amorous side. It has an intriguing history of uses and symbolism, and was once thought to be a sacred and magical plant. Elaborate customs using mistletoe evolved in England over the centuries, mainly as a fertility symbol and aphrodisiac. Kissing under the mistletoe supposedly came from the Norse legend of Balder the Beautiful, but it really became popular thanks to the Christmas-loving Victorians.

Mistletoe is semi-parasitic and found on only a handful of tree species. It was once a common sight in old orchards, growing high in the branches of apple trees. It uses the tree for food and support, although little harm is done to its host. The berries only grow on female plants and are attractive to birds, who eat them and then have to wipe their beaks on other branches to get rid of the sticky innards, helping to spread the seeds.

Mistletoe is thought to have several medicinal uses and has recently been investigated for use in cancer therapies and for its sedative properties.

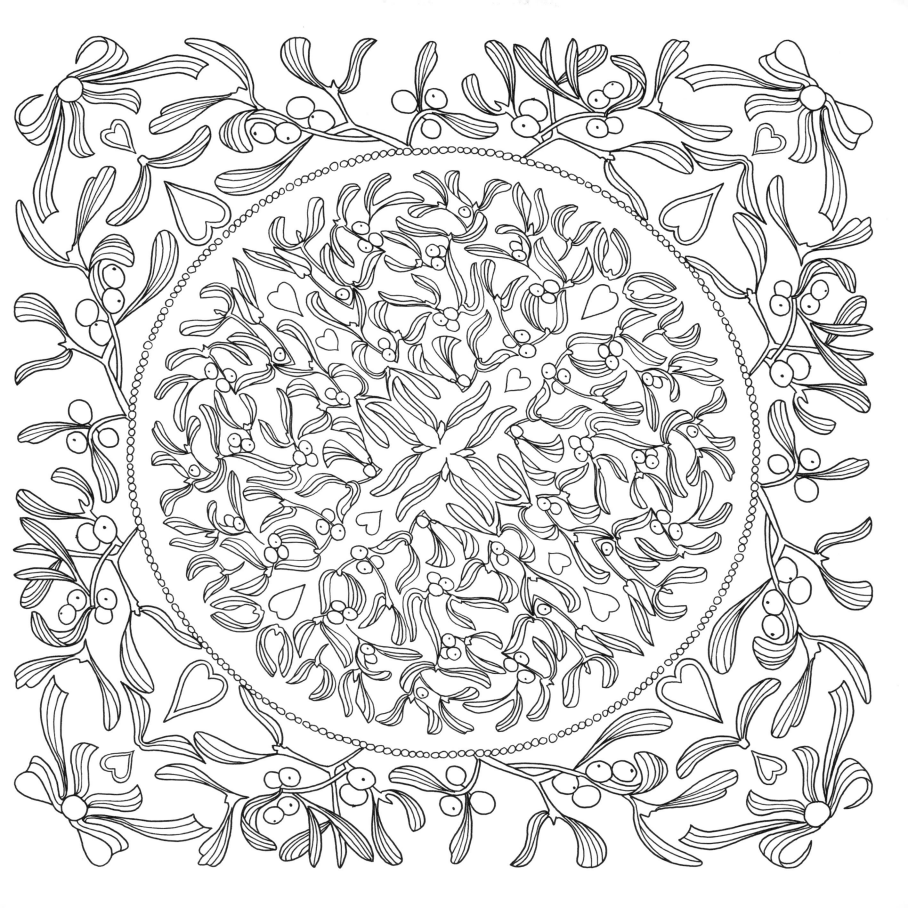

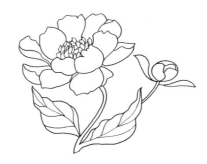

White peony
Paeonia lactiflora

Also called the Chinese peony, this beautiful, blousy flowering plant comes from central and eastern Asia. The large cup-shaped flowers are filled with a mass of bright yellow stamens, brimming with pollen. The white peony has been in western gardens for some time as it was introduced to England in the mid 18th century. It is the parent of many popular modern hybrids such as 'Bowl of Beauty' and 'Sarah Bernhardt'.

In China this peony is also valued for its roots, which have been used for over a thousand years to create a 'woman's tonic' in herbal medicine. It is also used for improving blood circulation. These effects are often said to produce a youthful glow leading to it being regarded as an 'anti-aging' herb. Many women have used white peony root treatments on their skin as well, to try to increase this effect and improve smoothness. In China there is an old saying that claims a woman who eats the root of white peony will become as beautiful and timeless as the flower itself.

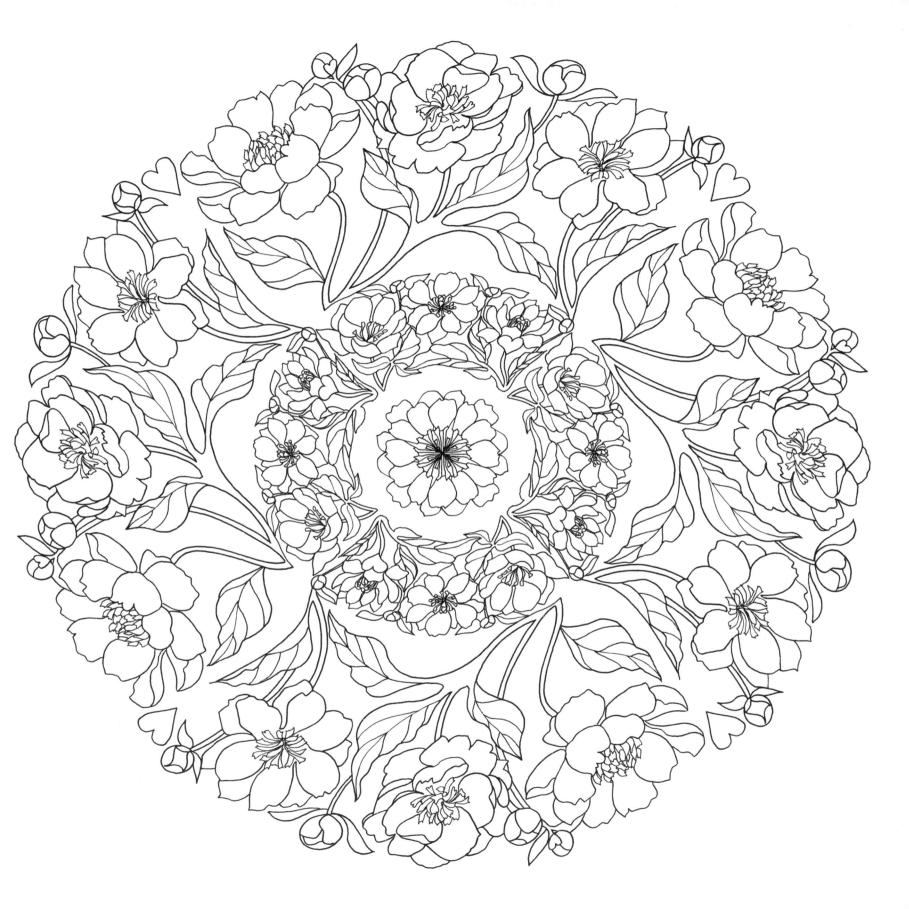